MALCOLM MORLEY

MALCOLM MORLEY

Rules of Engagement

SPERONE WESTWATER
257 Bowery New York 10002
T + 1 212 999 7337 F + 1 212 999 7338
www.speronewestwater.com

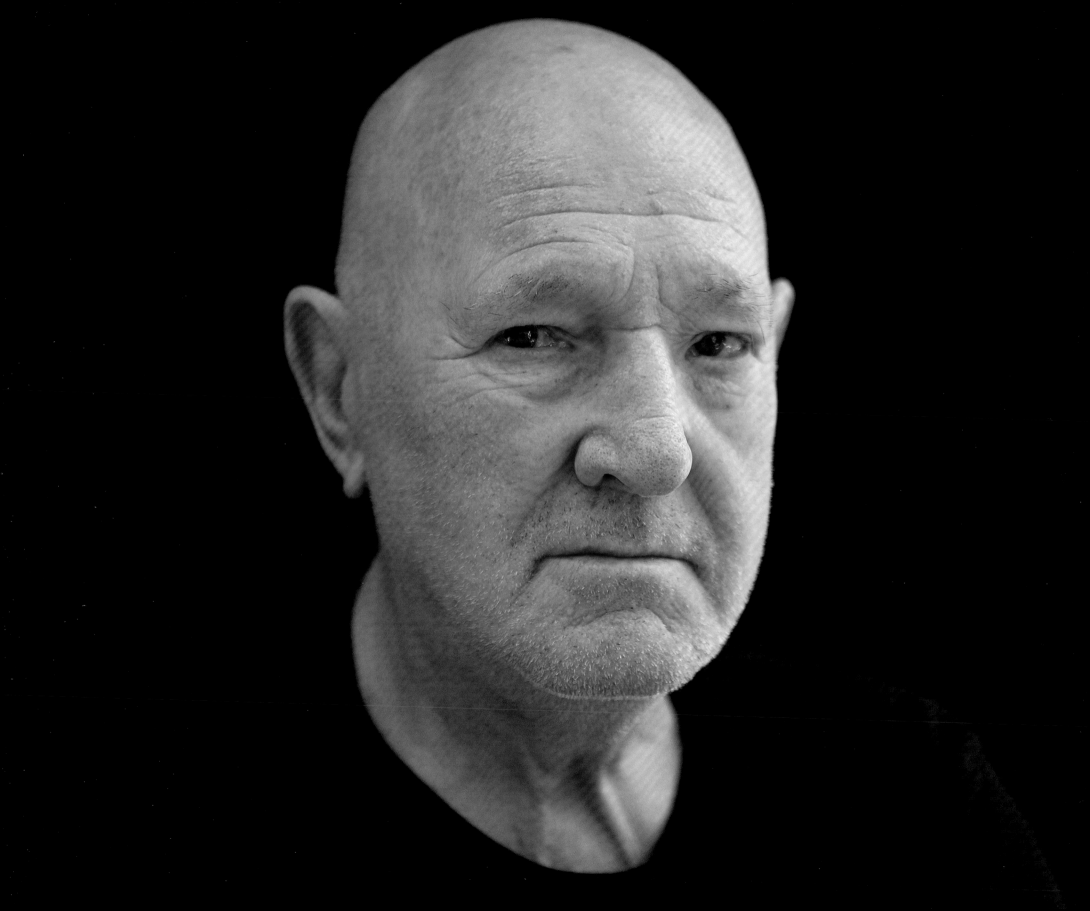

Malcolm Morley's Rules of Engagement

Brooks Adams

Malcolm Morley is, among other things, a painter of war. His art depicts the great arc of 20-century World Wars – the First and the Second are liberally intermixed in his oeuvre—but also ancient sea battles, the Korean and Vietnam engagements, and more recently the egregious batterings in Iraq and Afghanistan. Morley is a child of war, or better, a teen of war (born 7 June 1931 in London, England) – he famously lived through the Battle of Britain, watched air battles from his rooftop, placed bets on who was going to win, and wanted to enlist at age 12. If his early work is often given over to the escapist pleasures of leisure, his mature and late work has just as often settled on the subjects of war and destruction, both natural and unnatural, as paradoxical subjects of, once again, pleasure in painting.

In his post-2001 work, Morley has focused on heroes, specifically the contemporary American, warrior-like sports hero in formats ranging

from scrimmage/battles to head shots – motorcyclists, racecar drivers, baseball and ice hockey players, and at the more balletic end of the spectrum, skiers and swimmers like *Backstroke* (2004) -- so it seems only natural that eventually he would want to get back to that biggest sport of all, war, and focus on its heroes as well.

We get a sneak preview of Morley's new war stars in a 2001 large field painting *Rat Tat Tat* in which a small pilot's head emits a large bubble: "There it is, zeppelin at two o'clock!" In the new works, the aviator heads loom large, and the old bubble emission has been replaced by a big red stamp saying "Classified."

It stands to reason that when we read the word "Classified," as we do on so many of the *Fighter Pilot (Ace)* series, the word suggests that a kind of secret, or screen, between artist and viewer has entered the picture. According to the artist, the first "Classified" stencil went on *Belgian Fighter Pilot (Ace)* where it forms a bold diagonal, pressing against both pilot and plane. There the word is like a stuttered or broken phrase: CLA SSIF IED. The three clusters of letters are percussive and halting, like some lost code. Later Morley reworked the stencil, made it smaller and more focused, so that in *German Fighter Pilot (Ace)*, it appears like a neat little emblem or war medal – Morley compares them to license plates – part of the Luftwaffe pilot's military regalia – a welter

of circles and crosses repeated and amplified in the four stacked planes in and around the figure's head – all rendered without hierarchy, with equal intensity.

In Morley's new work, not to mention a post-Wikileaks world, the image "Classified" seems willfully old-fashioned, bordering on quaint. Although Morley's sources are as accessible, as democratic, indeed as Pop as Warhol's or Lichtenstein's, they have entered a very personal, encrypted, even fetishistic universe. The book on which these paintings are based sits on a work table in Morley's studio, there for me to peruse.

L'Homme à l'Assaut du Ciel (Man Conquering the Skies), was handed to Morley during his opening last year in Brussels by a young Belgian man, a stranger, who turned out to be Tom Liekens, a painter who announced himself as a watchful admirer. The many illustrations, in all their pulpy early '70s splendor, by Amedeo Gigli, offer a child-friendly history of flight from the myth of Icarus -- a subject treated many times by Morley -- to the first moon landing by Apollo 11. Morley told me he "took one look at the book, and knew this was it."

Morley began in April, 2010, with a scene out of Gigli's book depicting a World War II dogfight over water. The top-dog plane, an Italian S79 bomber, was considered so ugly that the French referred to it as "le bossu maudit" ("the bloody hunchback"). This hulking green behemoth becomes Morley's gorgeous *Strafing* – an allover explosion besmirching the palest of blues, flashing yellow at the painting's right edge. This is a battle painting in the Baroque sense. In this one painting, surrounding the S79, we see a whole morphology of forms ranging from tiny tachiste blurs in the distant "skies," to a crisply delineated, grisaille fighter-plane image at "mid-range."

The artist was sick during the spring and summer of 2010 and did not resume painting until that October. Then, for the next six months, he painted furiously, and the *Fighter Pilot (Ace)* series is the result of that intense burst of creativity. "I could do one in three weeks," he told me. "The paintings were like a redemption…. That was a close call… I believed in them more than anything I'd ever done."

Morley's own passion for actual flight is well-known. He was so moved, for instance, by the experience, some 20 years back, of briefly taking over the controls of a Concorde -- a very special treat arranged by Charles Saatchi, whose advertising clients included British Airways -- that he signed up for flying lessons shortly thereafter. Now Morley's airborne activity is limited mostly to painting, but it is no mere happenstance that his fighter-pilot portraits seem so lovingly specific: Manfred von Richthofen (the Red Baron), Walter Nowotny, Luigi Gorrini, James Edgar Johnson, Georges Guynemer,

Ivan Kojedoub – each a legendary aviator and war hero, each an Icarus of the modern era. "I call them my Roman heads," says Morley. "They are larger than life."

The forms in the *Fighter Pilot (Ace)* paintings are prone to metamorphosis. In *Crash Landing*, the green plane marked JJOB jams into the ground and loses a tire so prominently that the whole vehicle seems transformed into a racecar. The red sky and ground, with its striped red and violet orthogonals, say speed, '70s dandy style. In *English Fighter Pilot (Ace)*, James Edgar Johnson's pale green eyes rhyme disconcertingly with the target patterns on his Spitfire, depicted twice. (Morley mentions liking *The First of the Few*, Leslie Howard's 1942 propaganda movie about R.J. Mitchell, the designer of the super marine Spitfire.) Of the upper plane in the painting, Morley admits "I made a mistake with the wing. I was reading John Richardson's biography of Picasso at the time, and I thought, 'What would Picasso do?' So I added the fire and smoke. I also painted a double wing on the lower plane, and I kept it."

In *Major M.J.A. Morley of the 266 Squadron*, a new work that came in as I was writing this essay, the upper wing of a World War I biplane is rendered as oddly trans-lucent, like an insect's wing. What might have been grey and metallic becomes green and sentient. We see the flameout of one plane through the veined and leaf like wing of the other. Is this a self-portrait of "Major Morley"?

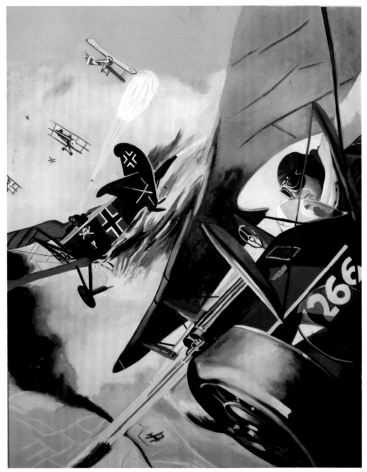

To view YouTube clips of the young Walter Nowotny's high Nazi state funeral in 1944 is to experience a real frisson. But Morley's portrait of him in *German Fighter Pilot (Ace)* is an expression of aviator worship, not an evocation of nationalism's past. Wikipedia articles about the great World War I French aviator Georges Guynemer (1894-1917), depicted in Morley's *Belgian Fighter Pilot (Ace)*, will inform you that he was venerated by French schoolchildren who were told that he flew so close to the sun he couldn't come down again, though he was in fact shot down near Ypres, Belgium. (Guynemer also lent his name to a posh street bordering the Luxembourg Gardens in Paris, near where I live.) In Morley's painting, he might as well be a 1940s Hollywood leading man.

Heraldic motifs suggest other metaphors. The Italian ace, Luigi Gorrini (born in 1917), has an ace of hearts emblazoned on his plane. This brings to mind the whole iconography of playing cards in Cubism, not to mention the early Cubist paeans to aviation, such as Robert Delaunay's *Homage to Bleriot* (1914). In *Russian Fighter Pilot (Ace)*, Ivan Kojedoub (1920-1991) has his chin so tight against the whirring blades of his plane; you might think he was getting a very close shave. The horizon in this work appears as a vertical… but no, Morley tells me, "I'm not doing a Baselitz." And in *Rules of Engagement*, of a 1950 Korean War air battle, a real paintbrush is attached to one of the depicted jet planes, vehicles first used during this Cold War conflict: the painter-as fighter has entered the fray.

Portraiture used to be a latent or repressed genre in Morley's art. He has painted likenesses since the '60s – for example, *The Ruskin Family* (1967),

a grisly breakfast table scene depicting Mickey Ruskin, the legendary owner of Max's Kansas City, the downtown Manhattan venue that Morley used to frequent. In the *Fighter Pilot (Ace)* series, the latent becomes dominant, the repressed explicit. The big heads fill the fields, as in movie posters. The big smiles – on board since *Ship's Dinner Party* of 1966 – become physiognomic displays of forceful intent – worthy of the great 18-century Austrian sculptor Franz-Xavier Messerschmidt (1736-1783), whose excruciating character heads (also self-portraits) were recently rediscovered in a retrospective at the Neue Galerie in New York and at the Louvre. Morley has finally done historical portraits in the Grand Manner – worthy of Sir Joshua Reynolds, first president of the Royal Academy of Arts, whose distinctions between genres still bedevil Morley's approach.

The 18-century classification of artistic genres in which portraiture was rated low, just above landscape, would have been absorbed by Morley in his 1950s fine-arts education at Camberwell School of Arts and Crafts in London. But Morley's ability to skew, confuse and reinvent traditional genres such as history painting or society portraiture is something he would have learned only in the tumult of 1960s and '70s New York, where he hung out with all manner of artists -- Pop, Conceptual, abstractionist, you name it.

Provocation is still a large part of Morley's war painting, though in the *Fighter Pilot (Ace)* series, it has mellowed into a beatific fixation on the faces, or "masks," of warriors. Only a few years ago, the provocation was much rawer. In Morley's living room stands an extraordinary object that, to my knowledge, has never been photographed. It's one of three *Military Objects* he executed in 2006: trompe l'oeil TVs that are, in fact, three-dimensional, freestanding painted models. This one depicts the beheading of Daniel Pearl on February 1, 2002, by agents of Al Qaeda. The object functions not only as a portrait, but as a portrait of a severed head, with red painted blood streaming down the shiny black socle. It's like a broadside from the French Revolution, or any of the countless depictions of the beheading of John the Baptist, or Judith and Holophernes – a completely riveting and unforgettable object that won't be exhibited any time soon.

Another TV war piece, *Military Object #1* (2006) was included in Ralph Rugoff's 2007 excellent exhibition "The Painting of Modern Life" at the

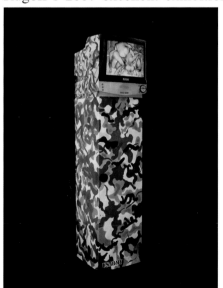

Hayward Gallery in London. There, according to Morley, "It was very controversial. There were viewer protests. A committee voted to have it removed from the show and placed in the museum lobby."

It was there on a rainy October afternoon, that I saw it and experienced the true force of Morley's post-2001 art. This smallish painted camouflage totem with its neat "U.S. Army" stencil near the bottom has as its TV image a delicious grisaille painting of piled up nudes. This derives from one of the 2005 Abu Ghraib photos documenting American soldiers' torture and humiliation of Iraqi prisoners. Morley's TV head, if not a portrait, then at least a totemic figure, stole the show, and blew all the other the photo-derived paintings – by no less than Gerhard Richter and Andy Warhol, among others – out of the water.

The first time I visited Morley's studio in June, 1995, there was a huge object hanging on the wall. This was a big red tondo with a full realized

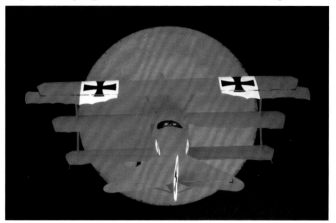

model of a Fokker VI triplane attached to it that jutted out in high relief. *Flight of Icarus* (1995) became for me the touchstone for just how far out Morley's obsession with model planes could take him. At the time I didn't grasp the iconographical fine point that the Fokker was the favored plane of the dashing Red Baron, aka Manfred von Richthofen (1892-1918), renowned to my generation mostly through Charles Schultz' cartoon-dog Snoopy.

Sixteen years later, in February 2011, I find myself again in Morley's studio, looking at the new painting *Ace of Aces*, his portrait of von Richthofen. In this portrait of a consummately pink-toned Teuton – all pursed lips and smoldering elegance – we see not one, but two depictions of *The Flight of Icarus*. But in *Ace of Aces*, the red sun and plane appear to tilt down and up. It's like a Roman narrative sequence in which a repeated motif signifies movement in time and space.

The colorful background of the painting, which so unnervingly rhymes with the figure's blond hair and rosy complexion, is based on a famous painting by J.M.W. Turner, *The Fighting Temeraire Tugged to Her Last Berth to be Broken Up, 1838* (1839) in the National Gallery in London. Why that particular sunset? "I knew Turner so well. I grew up on him. I took the image from a book. Did you know that Turner had a strong Cockney accent? At his Royal Academy of Arts lectures on color theory, no one could understand him."

Whatever we make of Morley's affinities with Turner, and there are many -- both artists' devotion to watercolor; their passion for painting naval scenes and shipwrecks; not to mention the fact that in 1984 Morley was the first recipient of the Turner Prize – nothing quite prepares us for the chance encounter of the Red Baron and the "Fighting Temeraire." This great combustion of military lore is part and parcel of what Morley calls his "historical ambition to join the pantheon of the greats." In beholding *Ace of Aces*, I felt sure he had a clear path to glory ahead of him. Happy Birthday, Malcolm!

Paintings

Beautiful Explosion, 2010
oil on linen
45 1/2 x 58 inches (115.6 x 147.3 cm)

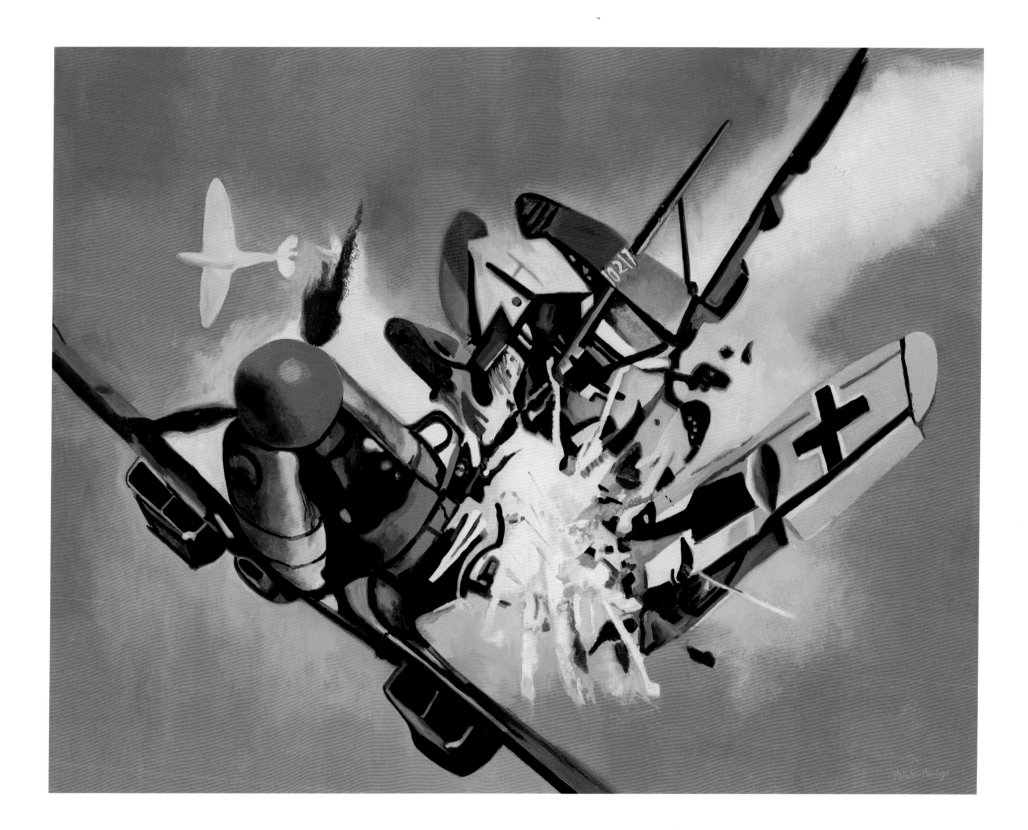

Russian Fighter Pilot (Ace), 2010

oil on linen

45 ½ x 58 inches (115.6 x 147.3 cm)

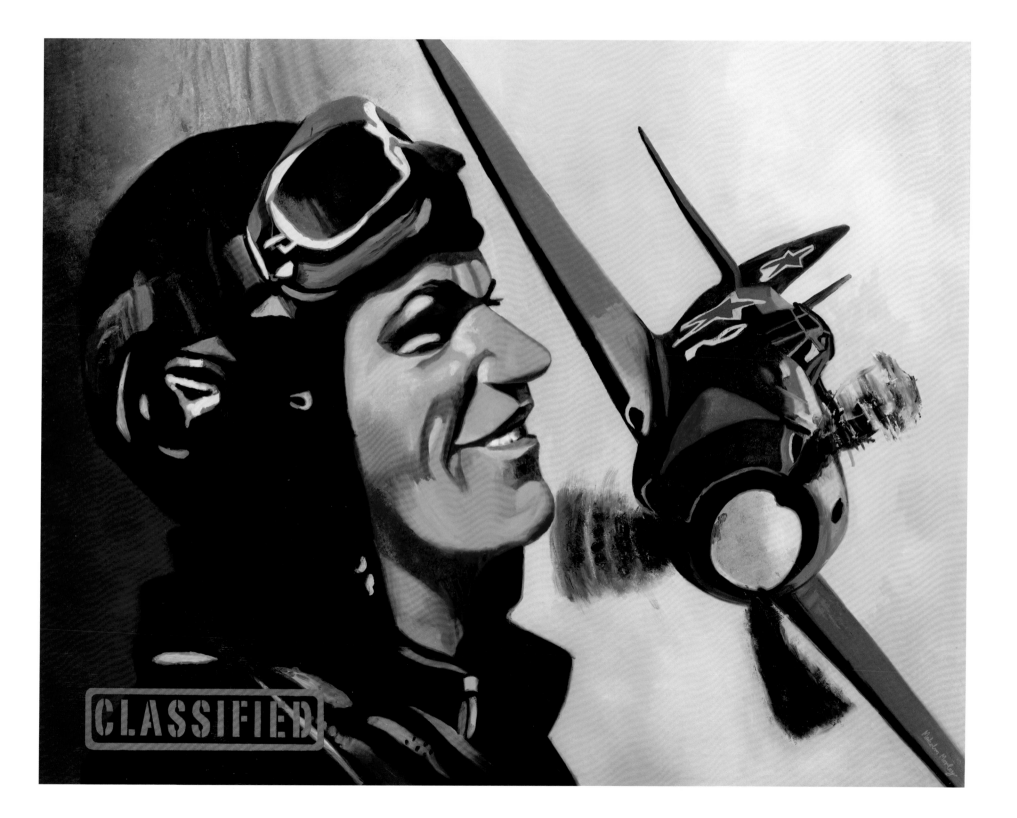

German Fighter Pilot (Ace), 2010
oil on linen
45 ½ x 58 inches (115.6 x 147.3 cm)

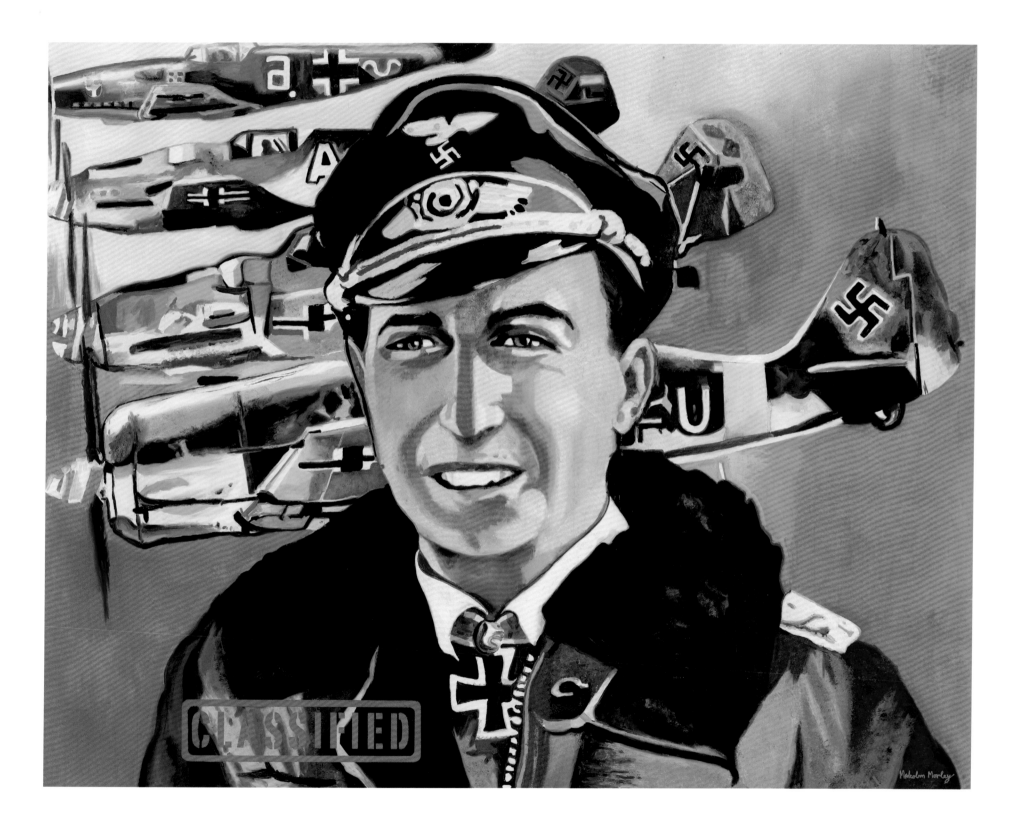

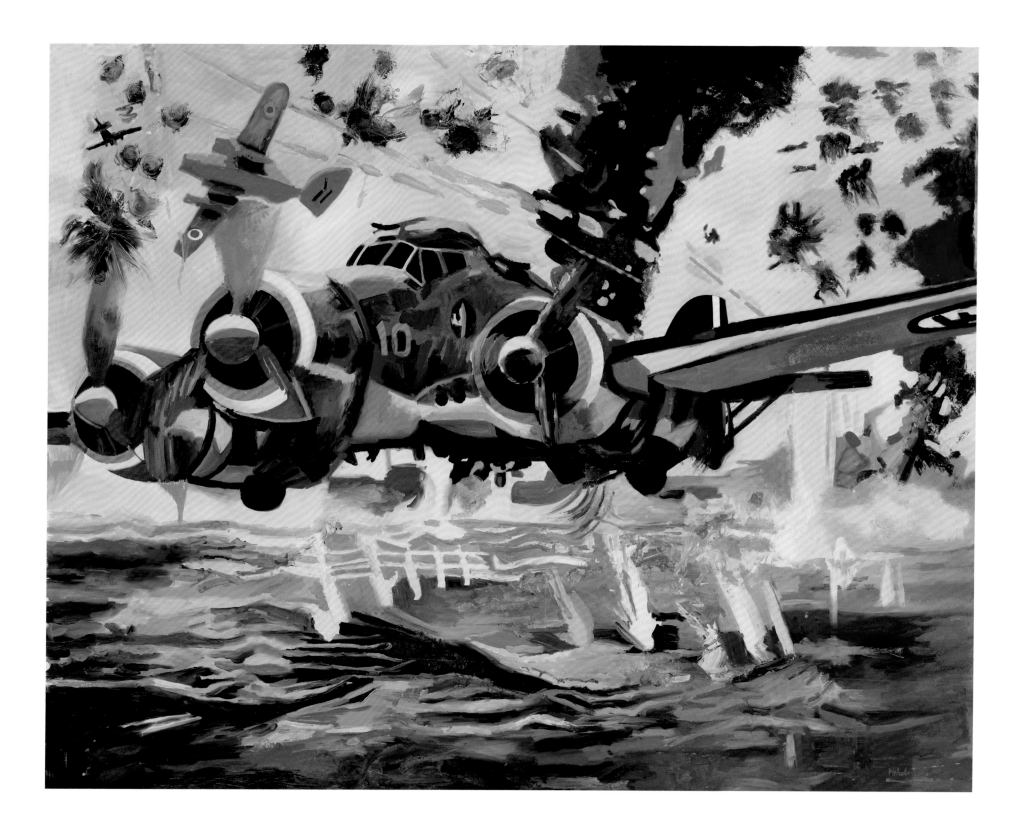

Ace of Aces, 2011
oil on linen
45 ½ x 58 inches (115.6 x 147.3 cm)

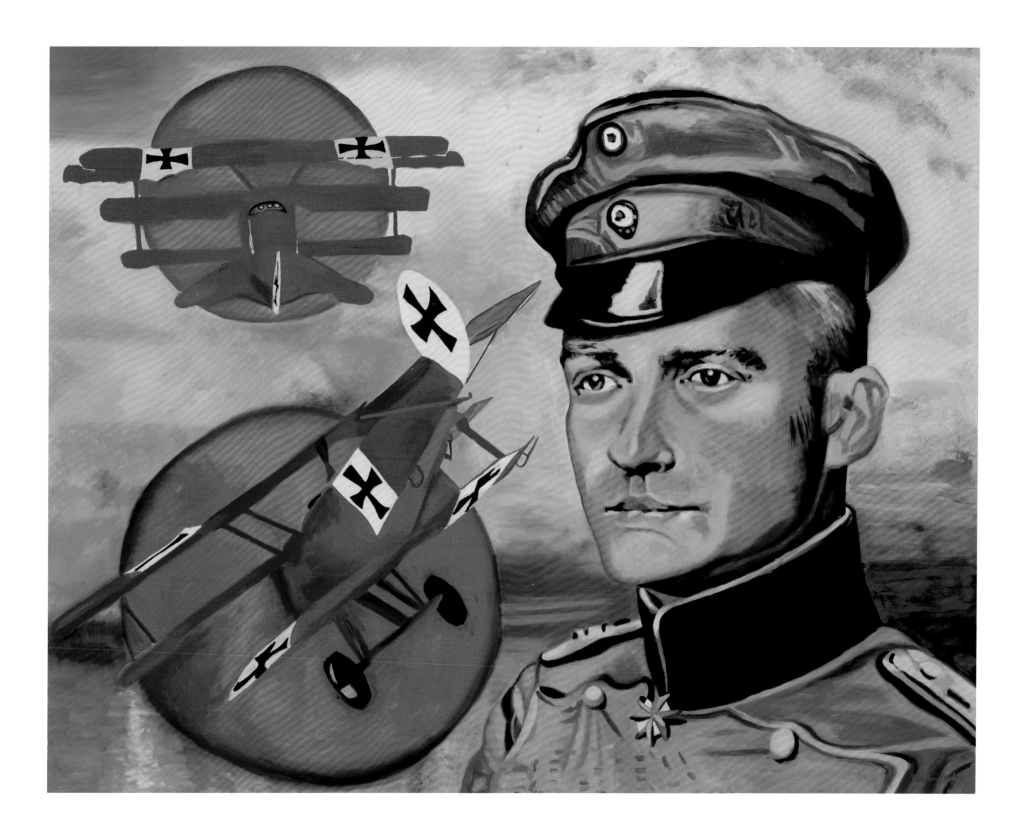

Rat Tat Tat, 2001
oil on linen
94 x 197 inches (238.8 x 500.4 cm)

Italian Fighter Pilot (Ace), 2010
oil on linen
45 ½ x 58 inches (115.6 x 147.3 cm)

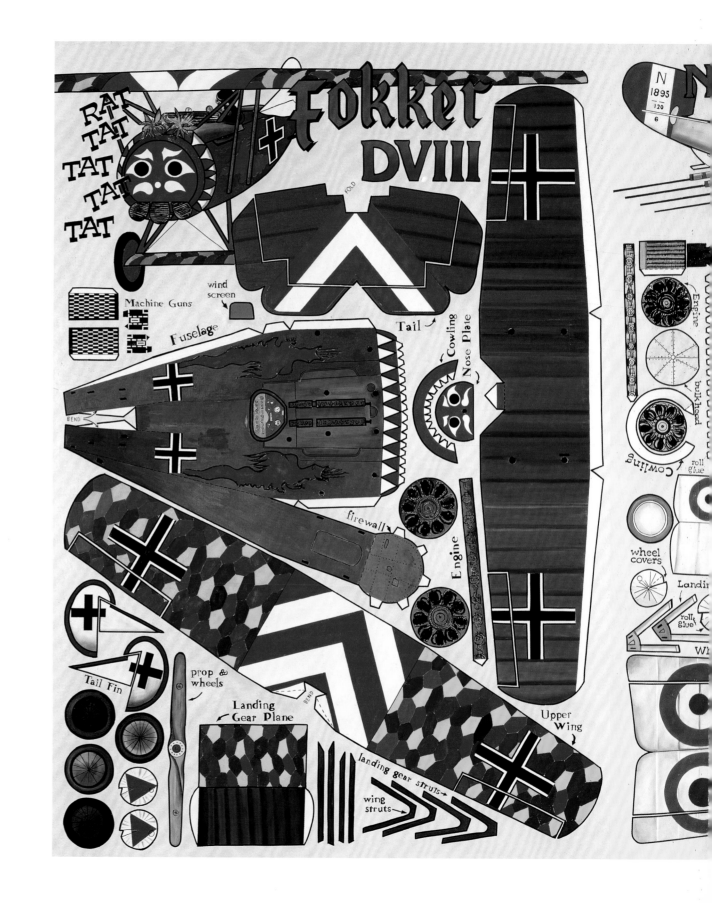

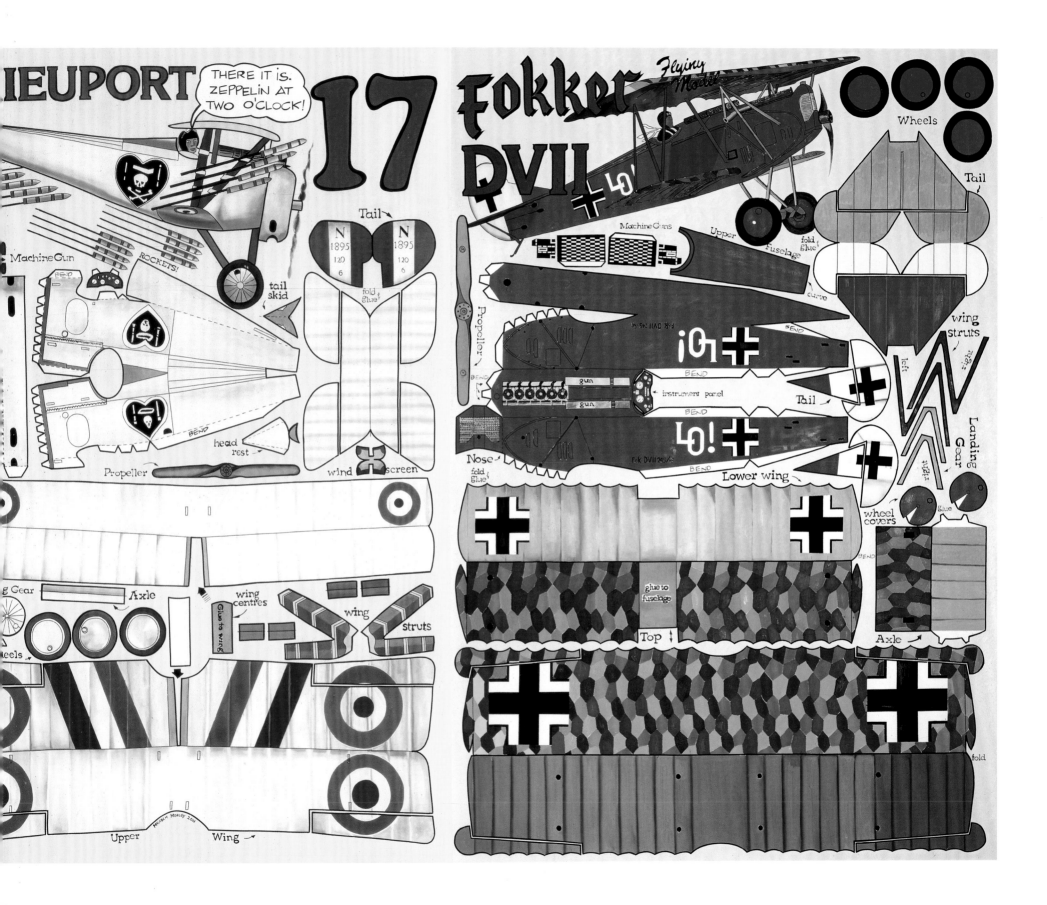

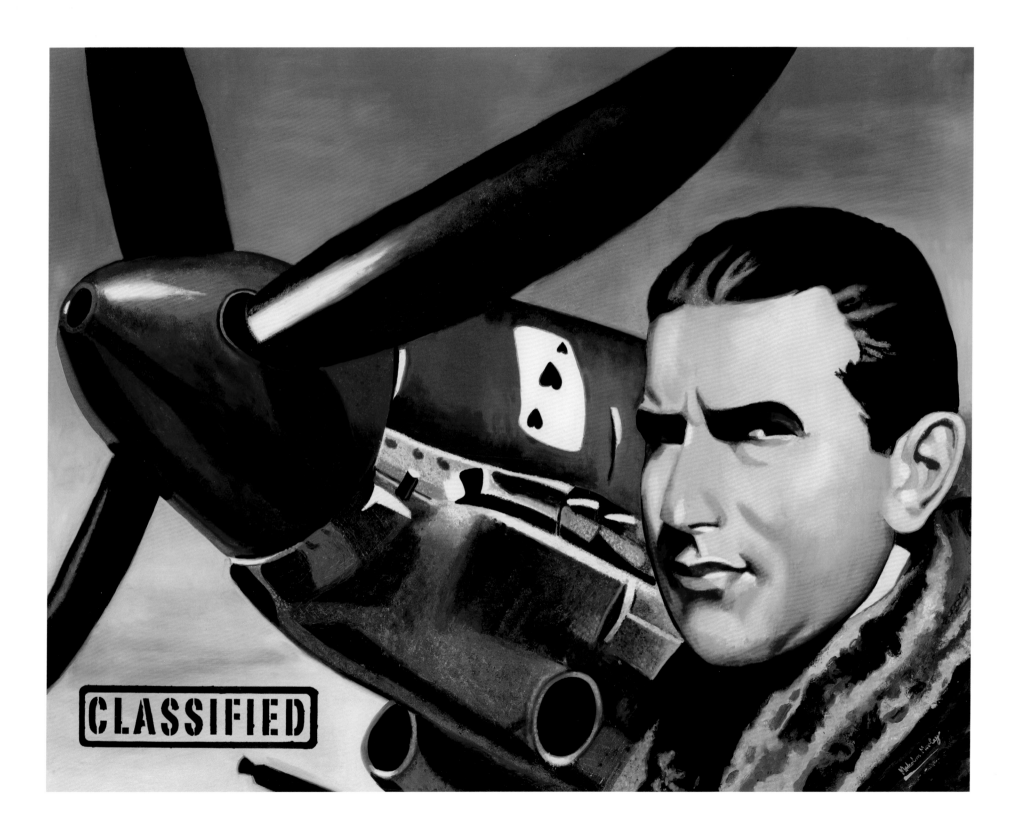

Belgian Fighter Pilot (Ace), 2010
oil on linen
33 x 46 inches (83.8 x 116.8 cm)

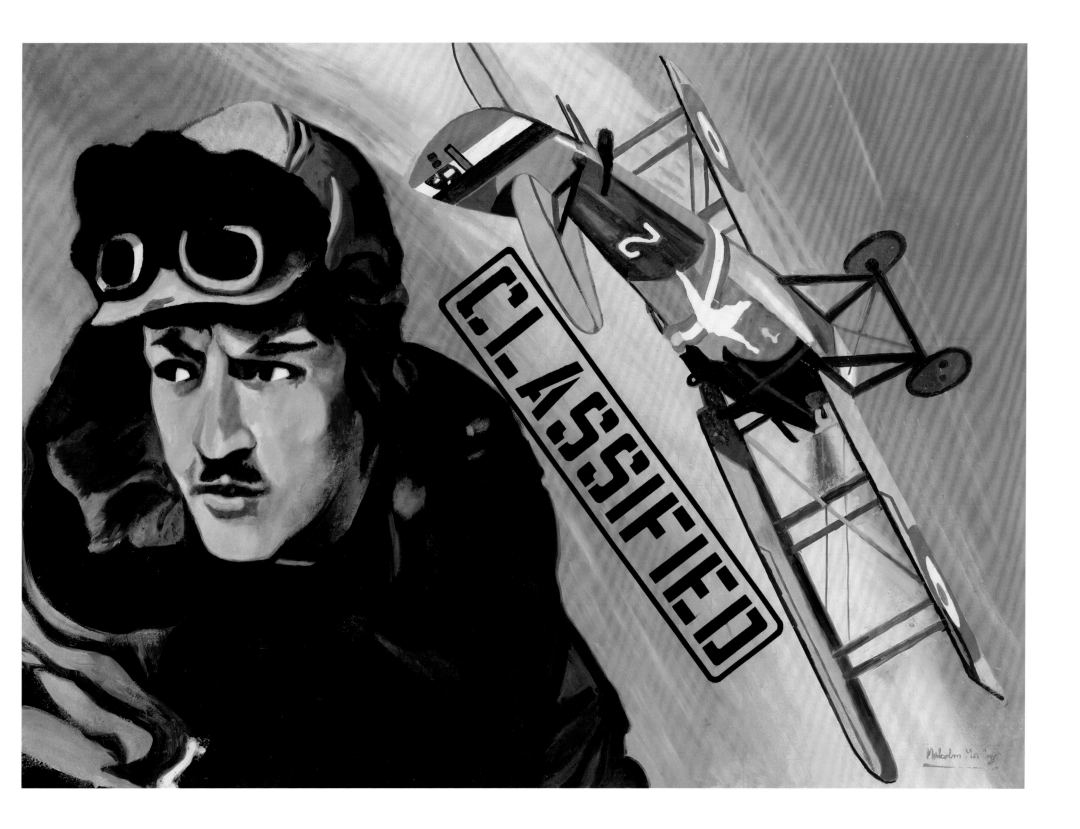

Rules of Engagement, 2011
oil on linen
45 1/2 x 58 inches (115.6 x 147.3 cm)

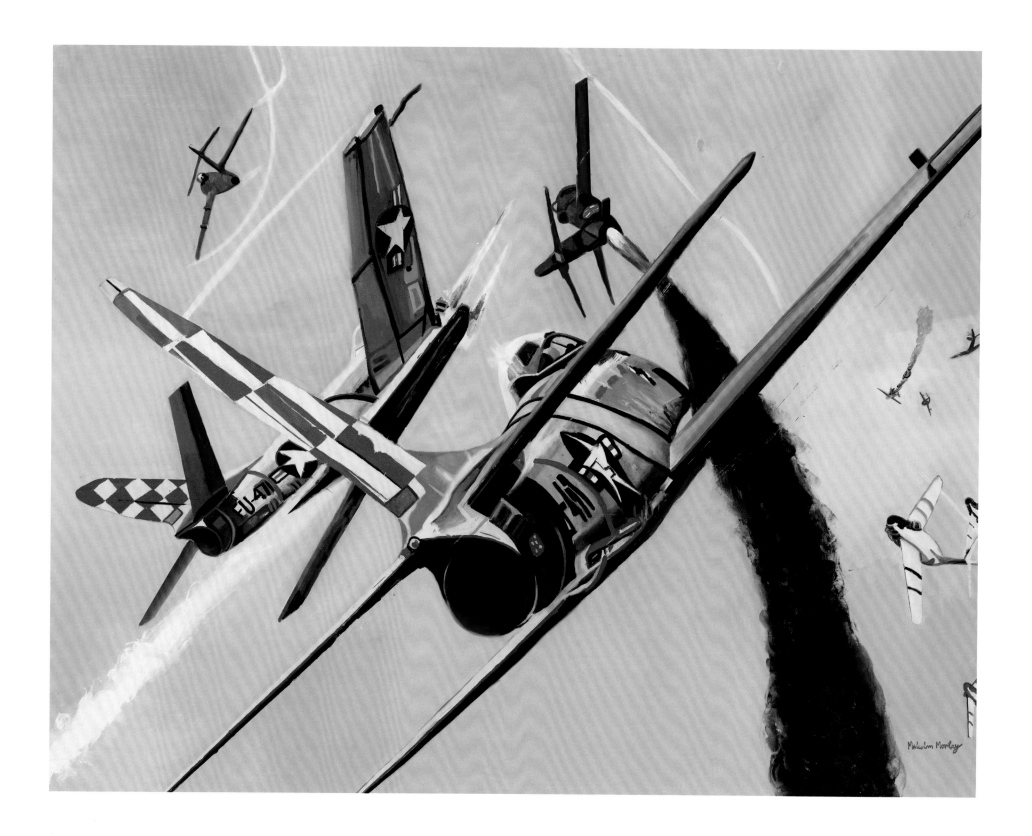

English Fighter Pilot (Ace), 2010

oil on linen

45 ½ x 58 inches (115.6 x 147.3 cm)

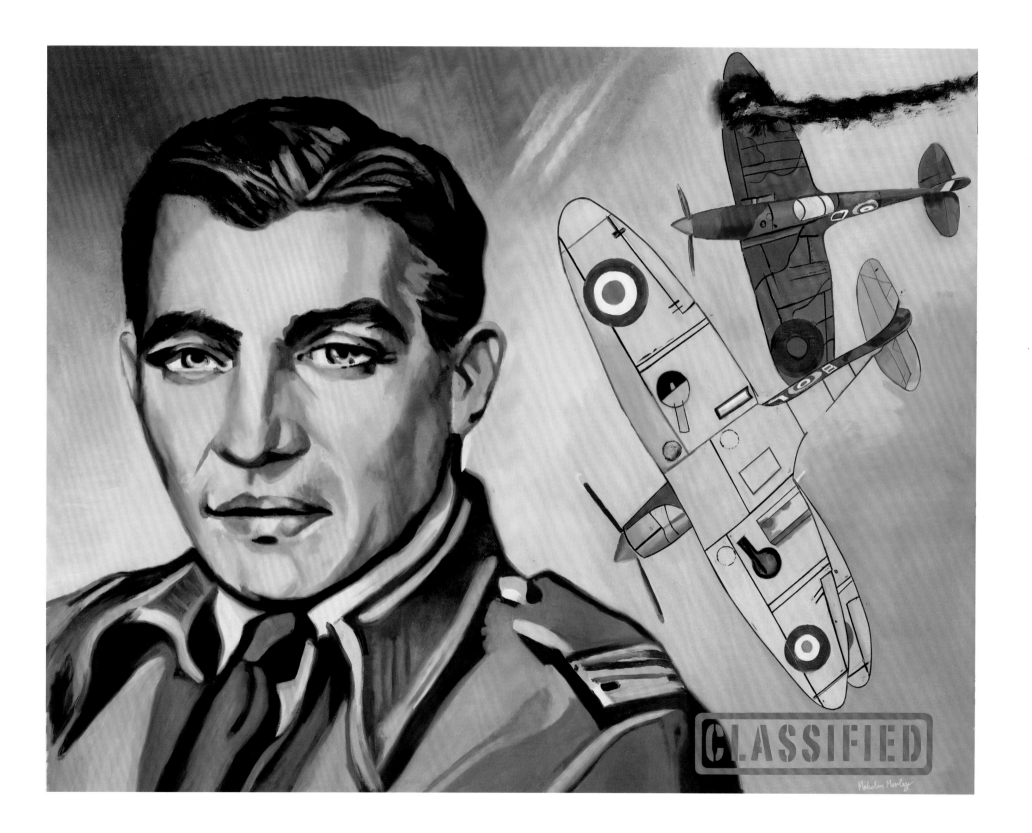

American Fighter Pilot (Ace), 2011
oil on linen
45 ½ x 58 inches (115.6 x 147.3 cm)

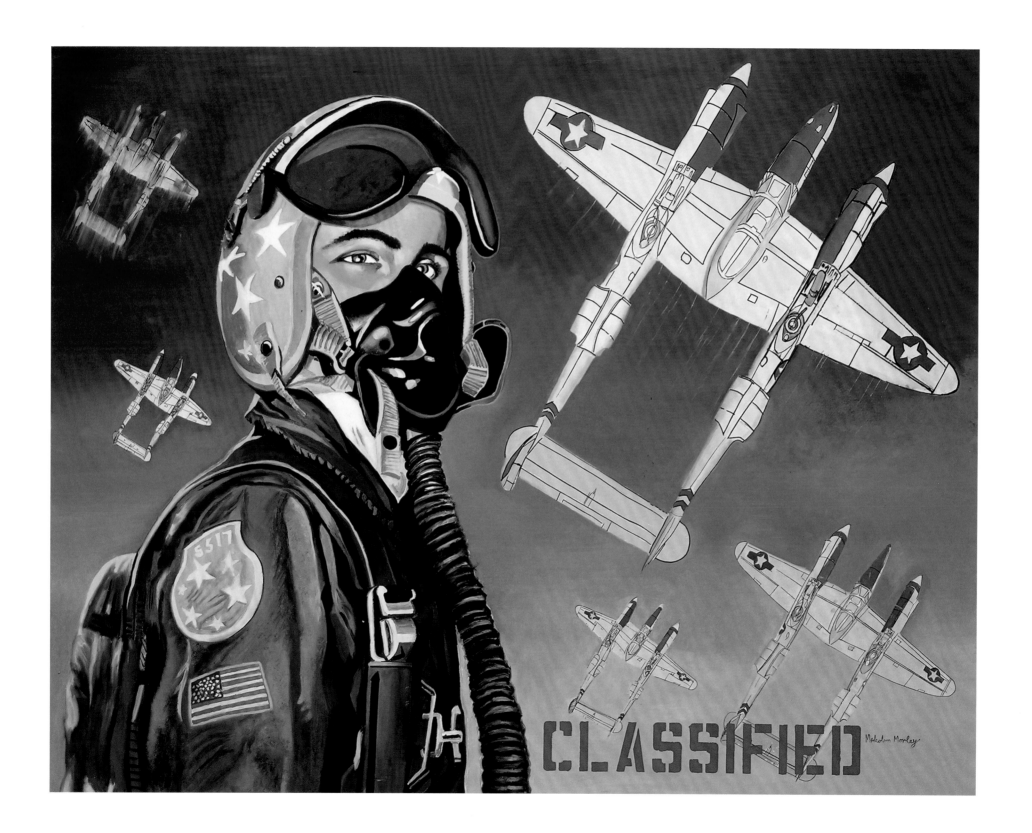

Crash Landing, 2010
oil on linen
45 1/2 x 58 inches (115.6 x 147.3 cm)

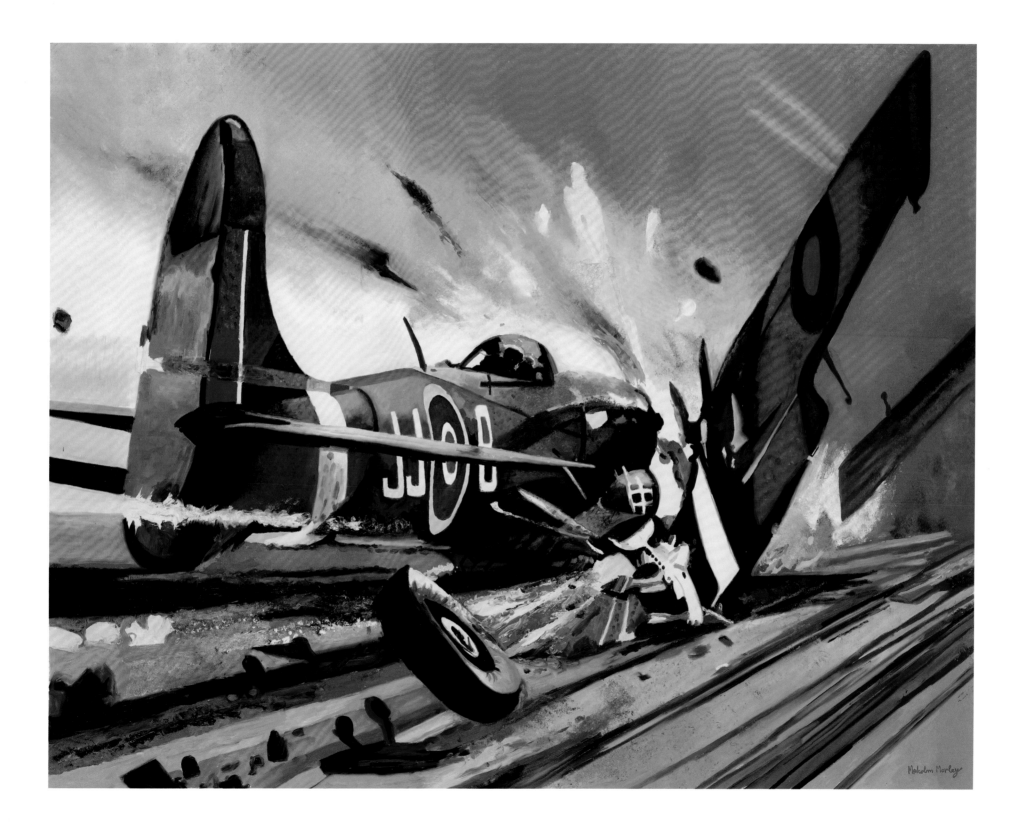

Malcolm Morley

Rules of Engagement

This catalogue is published on the occasion of the exhibition "Malcolm Morley: Rules of Engagement", presented at Sperone Westwater, New York, 31 March through 30 April 2011.

Malcolm Morley's Rules of Engagement © Brooks Adams

Design: Michael Short

Photography: Tom Powel Imaging

Portrait of Malcolm Morley: © 2010 Jason Schmidt

Printed in Montreal, Canada by Transcontinental Litho Acme

Published by Sperone Westwater, 257 Bowery, New York, NY 10002

ISBN 978-0-9828481-1-1